Chloé

© 2002 Assouline Publishing
601 West 26th Street, 18th Floor
New York, NY 10001
USA
Tel.: 212 989-6810 Fax: 212 647-0005
www.assouline.com

Color separation: Gravor (Switzerland)
Printed by Grafiche Milani (Italy)

ISBN: 2 84323 437 9

Chloé

HELENE SCHOUMANN

ASSOULINE

i grew up with Chloé. My mother, "Jeannette", owned the only boutique that carried the brand. Her boutique was like Chloé's beacon. My mother was her devoted and passionate ambassador. Sometimes, her customers even called her Chloé. I can still remember the dedication that Hélène Cixous wrote in one of her books in 1966: "To Chloé, the friend of their taste." Chloé was the woman's accomplice, she was fashion that spoke to their hearts. It was pioneering and embodied an audacious spirit, with gentle breaks from time to time. Chloé didn't wait for May '68 to complete her revolution. Her metamorphosis took place much earlier, in 1956, to be exact, with her first fashion show at the Café de Flore. Chloé brushed off the runways

like a student stealing the professor's sacred rostrum. Chloé invented a concept that would take the fashion world by storm, changing it forever: ready-to-wear luxury clothing.

by the end of the 1960s, there was no particular reason to go to this area of the 7th district in Paris where the Chloé boutique was located; nothing, if not for this store with the sandy colored sign and pink salmon rounded letters spelling out the word Chloé. With this boutique, the neighborhood's face changed and all of a sudden the whole world paraded forth. Buyers from the big American stores like Neiman Marcus, Saks Fifth Avenue or Bergdorf Goodman came to the boutique to look at the designs. My childhood was marked by these amazing meetings: I can remember Maria Callas, or Grace Kelly sitting dreamily looking at me with a benevolent smile. I can remember a mob scene caused by the hourglass silhouette of a woman's back, as she made a neighborly call: Brigitte Bardot. There was Jackie Kennedy, or Lauren Bacall fleeing the paparazzi flashes. I remember three Rolls Royces parked one behind another at the front door, causing a veritable traffic jam... The boutique's decorations were inspired by pop art, with walls hung with comic strips, attracting the world of show business. Sylvie Vartan came with her son David whom she held by the hand. She couldn't take her eyes off the racks. Claude François's dancers, the "clodettes", dressed in Chloé for their TV shows. When Christina Onassis came, everyone trembled. In a stentorian voice, she ordered thirty-six silk blouses as though it were a box of assorted bonbons. These printed silk

blouses were one of the brand's bestsellers: all the women adored them, in the same way that women now love Chloé's low-waisted pants. Chloé's fashion designer at the time, Karl Lagerfeld, turned to art books for inspiration: he tore out a page whenever he found a cubist or floral motif that he liked. Then four draughtsmen were in charge of reproduction, before the silk and wool merchants carried out their meticulous work. I found scarves that as a child I stole from Mom's wardrobe to dress up my Barbie dolls. I thought they looked much prettier and much more elegant dressed up in Chloé. They deserved to be framed and displayed on the wall like paintings.

nothing could stop Karl Lagerfeld and his thirst for creation; he drew voluminously. Karl would come to the house, rarely to the store, to which he would send his friends, Marlene Dietrich or Anouck Aimé. He seemed more like an orchestra conductor than a designer. I even thought he looked a lot like the great German maestro Karl Böhm, probably because of his black-framed glasses. He was very stern looking, very observant, and seemed always to measure his words. The cult of the personality surrounding designers, which developed within the ready-to-wear world, started with Chloé. Before that, designers remained out of the spotlight. Karl Lagerfeld survived it, and even spawned a whole generation of designer-stars whose names often preceded the very name of the brand. Karl Lagerfeld was a man in the right place at the right time. The spirit of Chloé was due to the alchemy of incredible teamwork. On Avenue Franklin Roosevelt, at the brand's head office, gaiety and a homey family feeling presided.

In those years, the brand was already well known. But Chloé's origins are much earlier.

The year is 1952, Elizabeth II was the Queen of England, and the hero of the year was the D-Day man: Eisenhower, President of the United States. In July, Eva Peron, nicknamed the Shirtless Madonna, died, as did the poet Paul Eluard, in November. Gaby Aghion, a young woman who had recently arrived from Alexandria, was one of his friends. Like him, she loved liberty, and bore a striking resemblance to Justine, the heroine of the Laurence Durrell novel *The Alexandria Quartet*. She came from a large Jewish Egyptian family that had adopted Western traditions. She was a cultivated intellectual, terribly audacious, with beautiful black eyes and a melodious voice. She avoided the confined salons of the haute couture, and wore suits and blouses of her own design. She was elegant and modern. Already, at an early age, she made sketches, knitted twin-sets. She hung out with writers, went on frequent walks in Saint-Germain-des-Prés, loved Paris, its atmosphere... She thought "the streets" dressed poorly. Back in those years, haute couture reigned for those women who could afford it; for the rest, often ill-advised copies provided by the neighborhood designer would have to suffice.

So Gaby made six dresses in cotton poplin which she put in a suitcase before making her way to a few boutiques that were highly respected at the time. With slim busts and full skirts, her designs emphasized the body's contrasts, slimming down the silhouette. Success came immediately, all her designs sold. In a small room in Neuilly, she started up a little workshop, hiring two workers, one from Patou and one from

Lelong. Thus her first collection was made. To her, the name Gaby sounded like a fortune-teller, so she went for Chloé, round and feminine, and borrowed from a friend, a manufacturer of fake furs, who agreed right away.

Chloé was born to delight women with full taffeta chiffon skirts, with large gussets that hold the waist. One dress, nicknamed "Embrun", was all the rage. Gaby Aghion looked through the magazine pages, *Jardin des Modes* or *L'Illustration*, gathering inspiration, transforming her designs, adding that personal touch. Soon, she could no longer manage her workload, and felt incapable of handling such success.

So destiny sent her Jacques Lenoir, a bored young man with jet-black hair and green eyes, and a Levantine look. An early member of the Resistance, Jacques, who was called Lenoir because of his hair, was one of those post-war disenchanted types, unable to find a place in the sun. Delighted at his meeting with Gaby, he plunged into the adventure. He had no fashion experience, but had passion and a business sense which would put Chloé on the road to success. Ready-to-wear boutiques started popping up and it seemed as though nothing could be more natural than to find Chloé in fashion's new hangouts; places like Marie-Martine on rue de Sèvres or Rety on rue du Faubourg Saint-Honoré. The round label was created.... And for the color, Gaby Aghion chose a hue from the Egyptian desert, born from nostalgia for her childhood: sunset pink. Throughout the years, Chloé remained faithful to the subtle shades of the desert: sand, pink, powdered hues in clothing, but also the perfume which has the warm color of amber. After the success of

the show at the Café de Flore and on the advice of Maïmé Arnodin, Chloé hired a young designer who had just finished his military service: Gérard Pipart. The year was 1956 and he created a straightforward collection using supple, soft fabrics, with a new concept: the woman slides into her clothes.

Over the last fifty years Chloé has always had the knack of discovering that rare, untapped talent, giving a chance to young men and women like Karl Lagerfeld, Martine Sitbon, Stella McCartney or Phoebe Philo. Gerard Pipart made a superb collection, but it was Gaby's designs which continued to sell because, true to the Parisian sense of chic, women preferred Chloé's unique, simple, ephemeral style with pure lines. Modern clothes which speak their language. Then came the emergence of the Left Bank with one designer after another: Christiane Bailly, Tan Guidicelli, Graziella Fontana, Maxime de la Falaise who gave a new tone to Chloé with sublime muslin dresses which would be among the great classics of the brand. These dresses were immediately a huge sensation. Michèle Rozier, editor at *Elle*, provided great media coverage for Chloé. Journalists have always praised the style of Chloé. The press loves Chloé, and fashion à la Chloé is deemed to be both avant-garde and timeless. Clothing is refined, well-finished, creative, with materials often used other than as initially intended: Chloé was the first to make dresses in jersey cloth, a fabric that was usually reserved for sweaters. Chloé was selling charm, dreams, something indefinable, unique. No surprise that years later, glasses with little heart engravings would take the fashion world by storm.

In 1965, Karl Lagerfeld, after having spent a year with Patou, was hired as a designer at Chloé. He was a cultivated young man and he and Gaby Aghion got along famously. An avid reader, he knew his literature. With much humility, he learned his craft. His arrival marked the beginning of Chloé's wonder years. Chloé became the designer to stars, who found their true bearings in Chloe's relaxed chic. Coats, divided skirts, suits, the day was more important than the night. Chloé was able to capture a form of spirit and beauty in the pleats of a long skirt, in the prints, in the soft silk: a second skin. The chic hippies swore only by Chloé. Foreigners flocked to the brand, especially Americans. Chloé was now found in the most important points of sale in the United States.

another important date: 1974, the beginning of a new era, with the creation of a perfume, one of the firsts in the ready-to-wear business. How to get it right? Gaby knew all about the great perfumes of the time, so she recognized that associating the name Chloé with a perfume was a true challenge, which she met by commissioning the famous cosmetics brand Elizabeth Arden for the work. After six months of trials and testing, only sketches were needed to complete the enterprise. Everywhere Gaby went, she would take with her a cloth dipped in the fragrance, so everyone she knew could smell it and give their opinion. The whole Chloé house came alive, the very walls inundated with heady fragrances. I can still remember the day when Gaby, in her "uniform" pinafore dress and cream-colored blouse burst out with her habitual passion: "We've got it!"

The results went beyond their wildest dreams. Chloé perfume was a success and fitted perfectly with the fashion of the time. The bottle was round with two big calla flower branches on top. The fragrance was flowery, with tuberous overtones, creating its own niche in the new tonalities of fashion; the amber color of the perfume was warm and sensuously inviting, a marvel seemingly embodying all of Chloé. It was most loved and copied in the United States. A few years later, the famous advertisement showing a woman dressed in Chloé inside the bottle, would go round the world, with the slogan "Become Chloé". The perfume was ready and to announce its birth, Chloé wanted to keep in close touch with its audience, so it was only natural that, during the 1974 fashion show, a model walking down the runway held out her hands carrying the new Chloé fragrance. It was a triumph, an ovation, Chloé had won again.

The brand took off. Chloé was exported the world over, including entire lines of fashion accessories.

I n 1983, Karl Lagerfeld, called to other destinies, did not renew his contract. Chloé had to continue without its Daphnis but each designer who followed would add his brick in the Chloé edifice. Jacques Lenoir and Gaby Aghion, as free spirited as ever, let the creators express themselves. Guy Paulin, with his very pure, feminine lines, drew away from the baroque nature of Karl Lagerfeld. Philippe Guibourgé gave Chloé its evening touch, designing muslin dresses covered in multicolored pearls, or diaphanous dresses circled in gold, harking back to the Roman empire; these fantastic creations were a

huge success. Peter O'Brien, a designer who would later work with Rochas, would add a very personal touch owing to his great sensitivity: dresses in taffeta chiffon with great trains, or an irresistible collection of mohair jumpers.

Dunhill Holdings bought out Chloé in 1985 and, respectful of the brand, kept the same spirit, continuing to develop new sales outlets in the major capitals around the world. Gaby Aghion and Jacques Lenoir withdrew: a new generation was to arrive.

martine Sitbon lent to the brand her absolute femininity and strict chic: black dresses with open necks, navy blue and white ensembles, as well as very structured suits in various colors. She created for Chloé a new style ahead of its time, that of the modern women. Her timeless fashion has not aged and her talent was confirmed by the growing success of her own brand.

1992, bingo: Karl Lagerfeld came back to the house and signed the Chloé collections for several years. He set a new direction, understanding the era without pastiching the Chloé of previous years, on the contrary. Karl's women became contemporary women – though usually keen on rich material, he gave them a new texture: fluidity, softness, introduction of pastel colours, new shapes.

Double or nothing, Chloé has never shied away from a gamble. By hiring Stella McCartney in 1997, Chloé made a 180-degree turn providing a new youth, a forgotten lightness. Here we see a return to Chloé's beginnings, that audacious, pioneering atmosphere, just a touch heretical. This rock-n-roll girl was friends with pop stars' children, with Kate Moss, Madonna, Cameron Diaz, all dressed by their girlfriend. An heiress to Carnaby

Street and Mary Quant, Stella is English to her fingertips and discovered in fashion the call to the 1970s clothing worn by her mother, Linda, who wore Chloé. Charming nudity is now the style, old-time lingerie or the sexy tomboy, it is all in the trousers' cut: Chloé invented those low-waisted pants which make the hips swing, while showing off the belly button.

Ultra-feminine, young, with little nostalgic accents, it's a gentle revolution, about which her father, Paul, sang with the Beatles when she was a little girl. T-shirts are printed or embroidered, and grabbed like Chloé's silk blouses once were. The street energy once again finds a conductor. Printed materials, muslins, always shifting, always mixing, jeans and satin, tweed corsets on a sequined skirt: we are in an era of crossings, and Chloé felt it.

t he girl generation has arrived… Girls who dressed up in their mothers' clothing now have their own collection. Also a graduate of the famous St. Martin School of Art and Design in London, Phoebe Philo worked with Stella at Chloé before taking up the flame as artistic director. No showing off for this young English girl with a contemporary physique and an enigmatic smile. Chloé's fashion, as depicted by Phoebe Philo, belongs to no style, no trend, no school. It is an entirely personal fashion casting its gaze on today's woman: a free and new spirit. Without spelling it out, the young designer renewed the dialogue with Chloé, embodying it once again, making its image readable: sensuality, fluidity, energy. Phoebe Philo loves…. the softness of fabrics, the way they hang, embroideries on blouses or wound around the neck. With her pure lines, Phoebe delivers us unclassifiable femininity, far away from extravagance.

How can one describe the Chloé woman of today? She's sexy, elegant, indestructibly feminine. She is serene, generous, enthusiastic. The brand presents its own version of fashion, walking forward hand in hand with history. Chloé has tied the knot between the values of the woman of yesteryear and the woman of tomorrow with the grace of eternity and timelessness. "Phoebe's touch" is born, a bit off center, aerial: current.

I went to visit the last collection, and I couldn't find the people I once knew there but what I did find was that same Chloé spirit I used to know, the fashion show going by like a long ribbon of memories bearing no notches. The entire memory of these past fifty years marched to the beat of a different drummer, but just as strong, just as moving. On the pediment of the runway the same round letters were traced out, as before, as always.

"Chloé is a pearl," Gaby Aghion used to say. "I give it to you, it is pure, spotless, so, please, don't spoil it!"

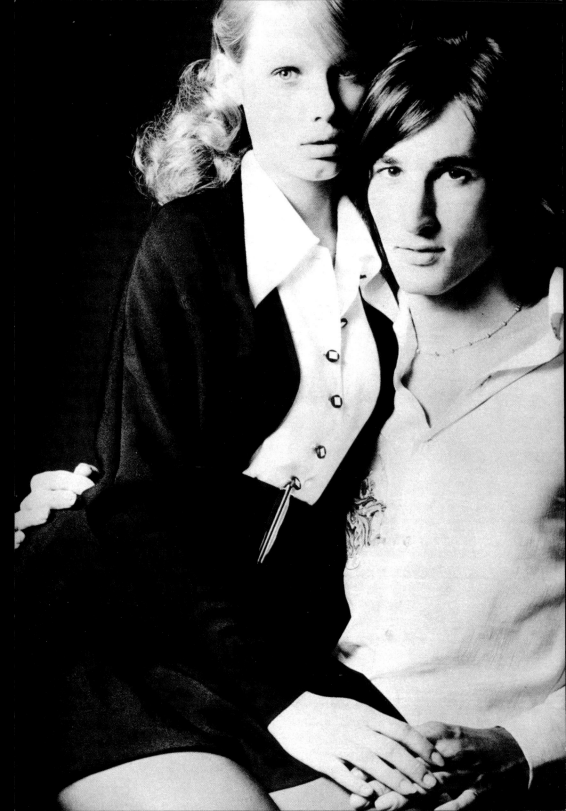

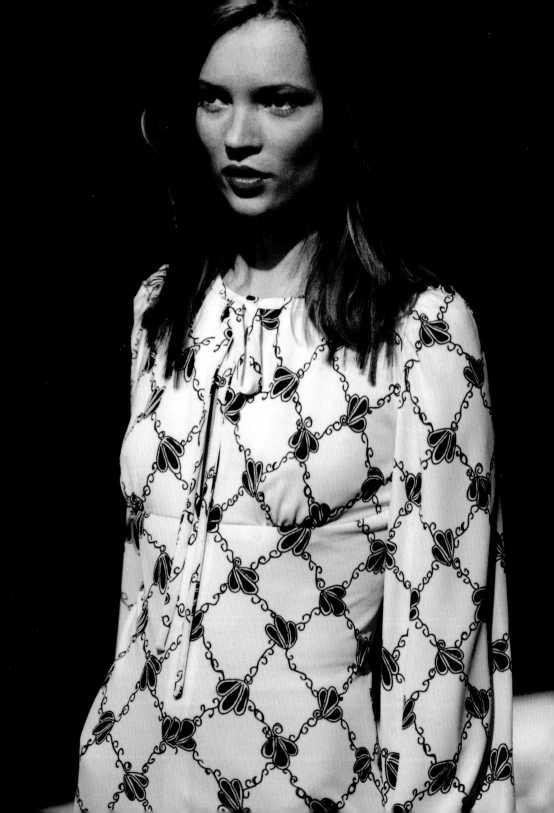

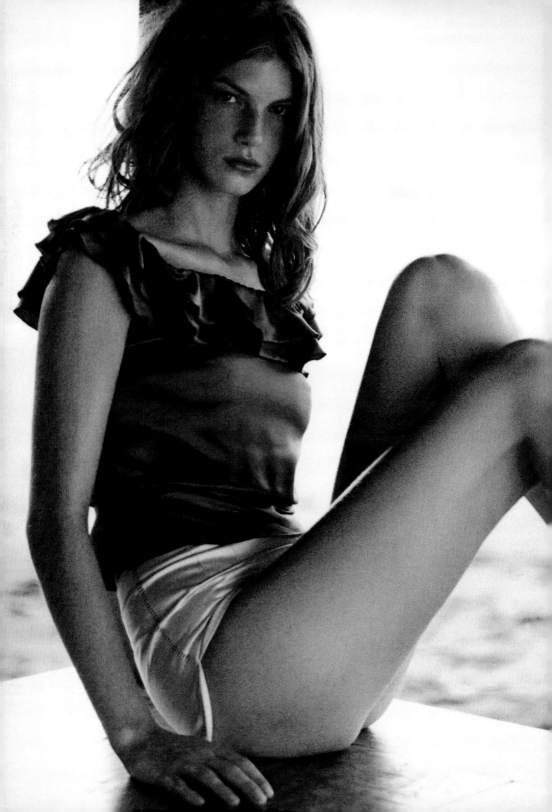

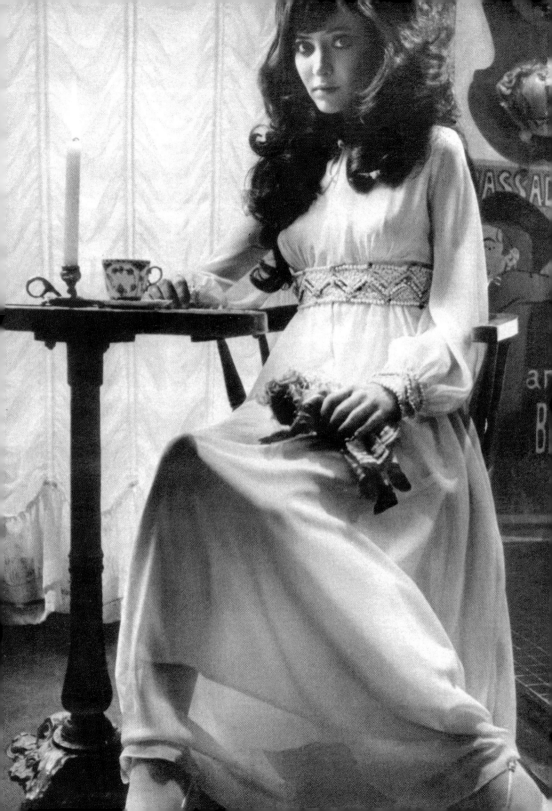

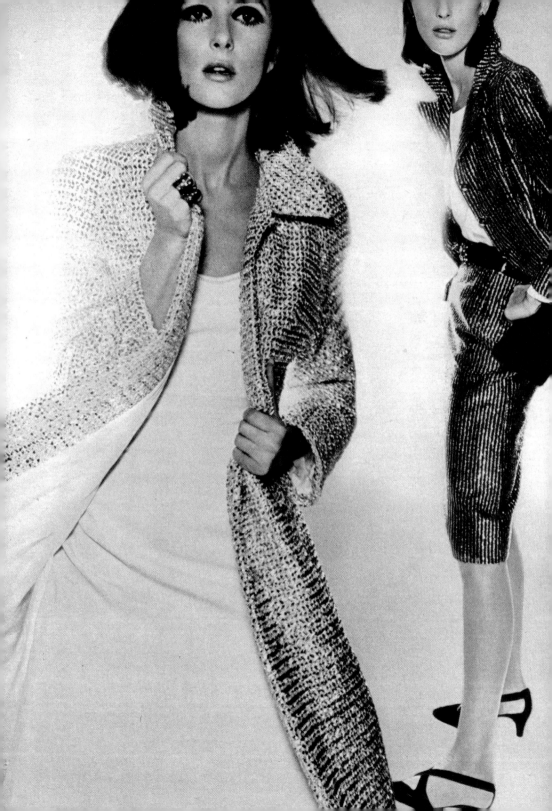

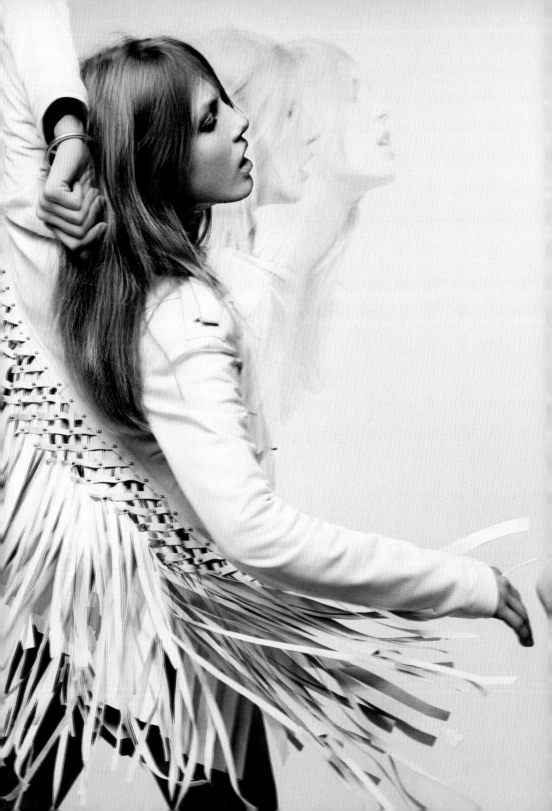

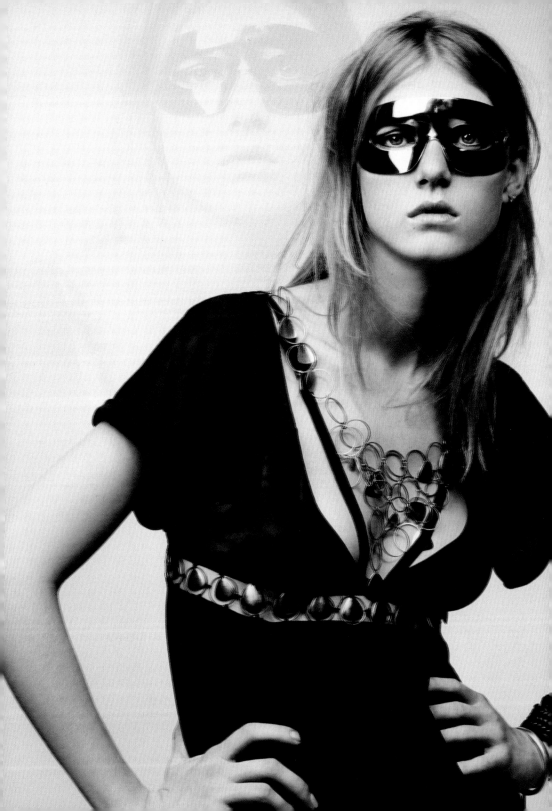

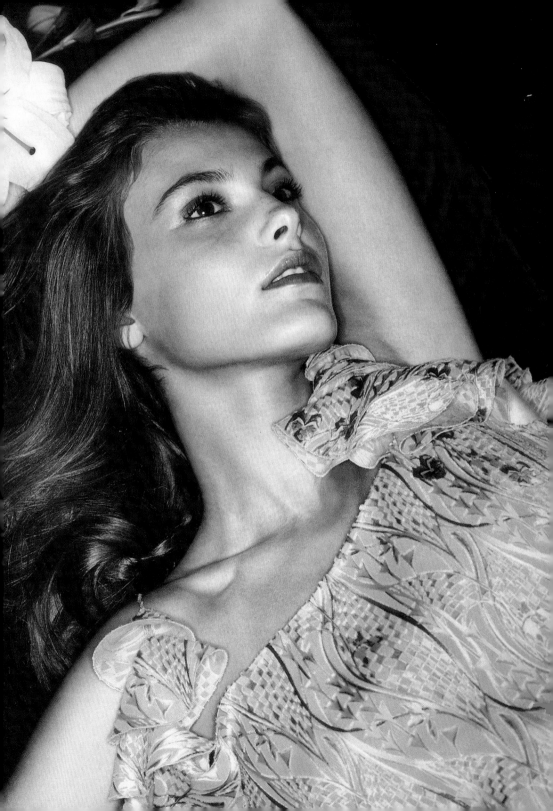

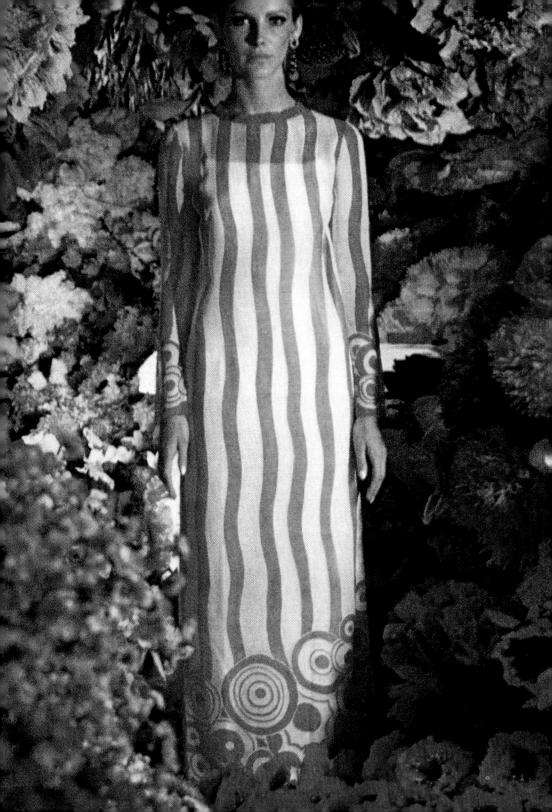

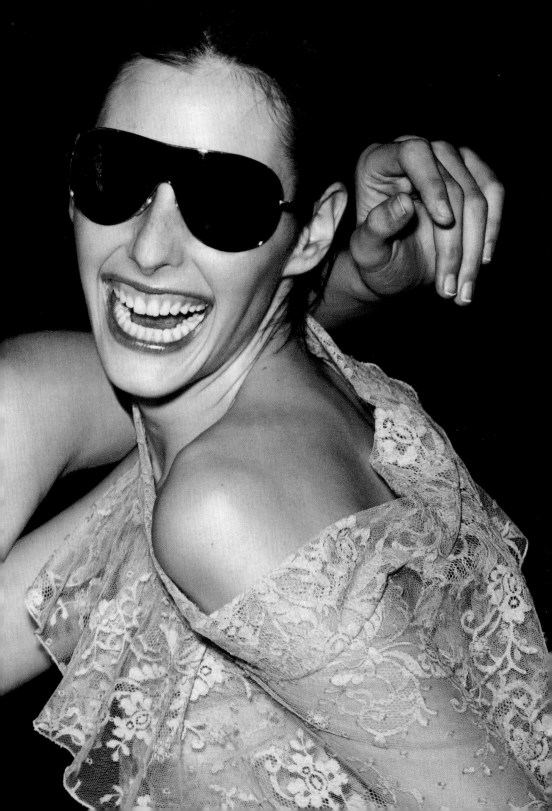

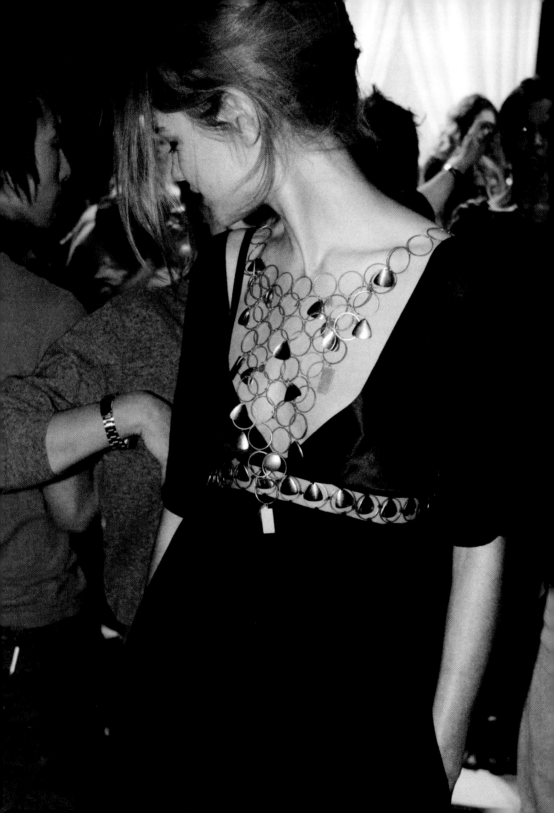

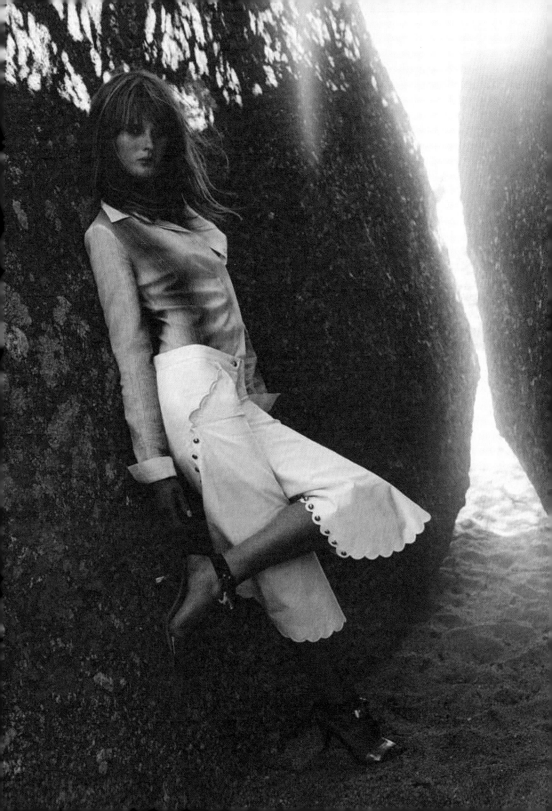

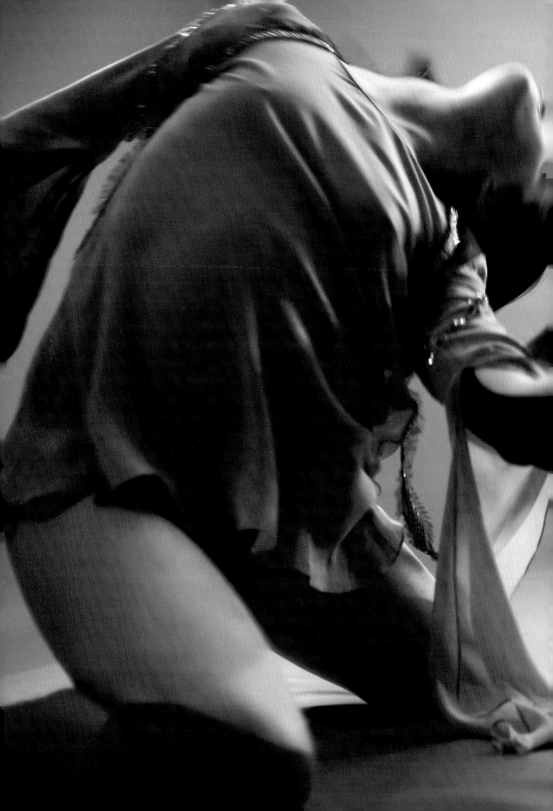

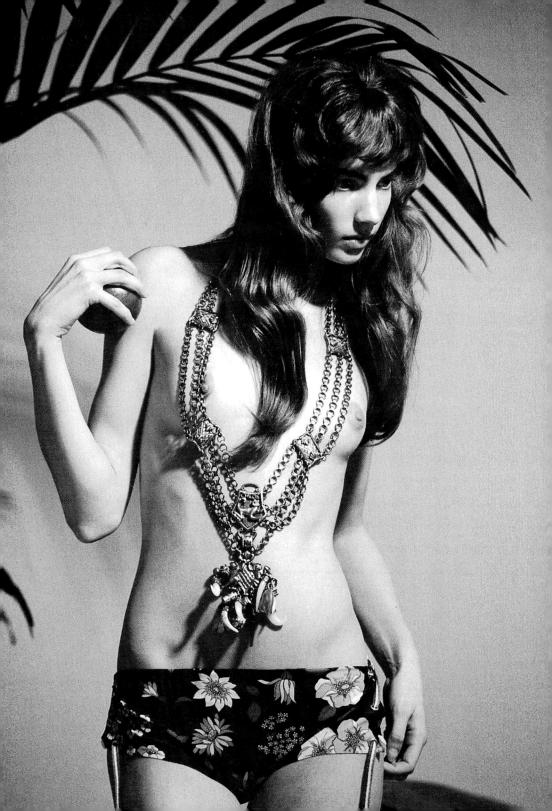

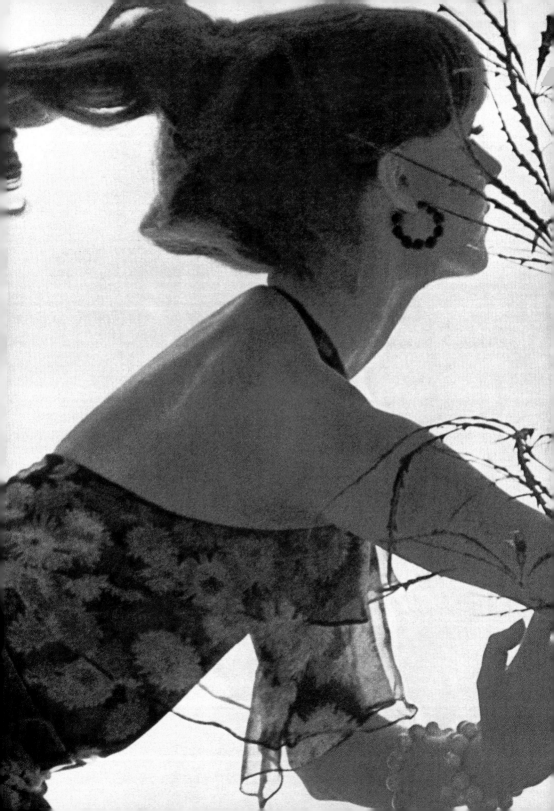

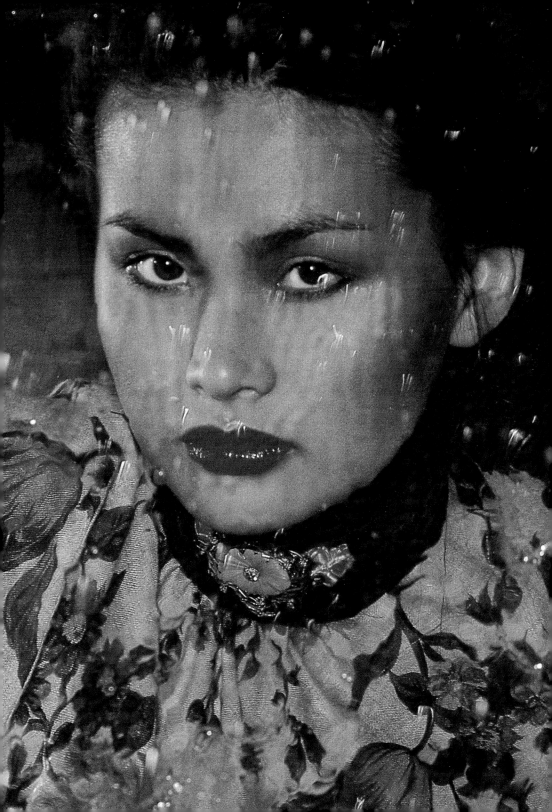

Chloé

été 94

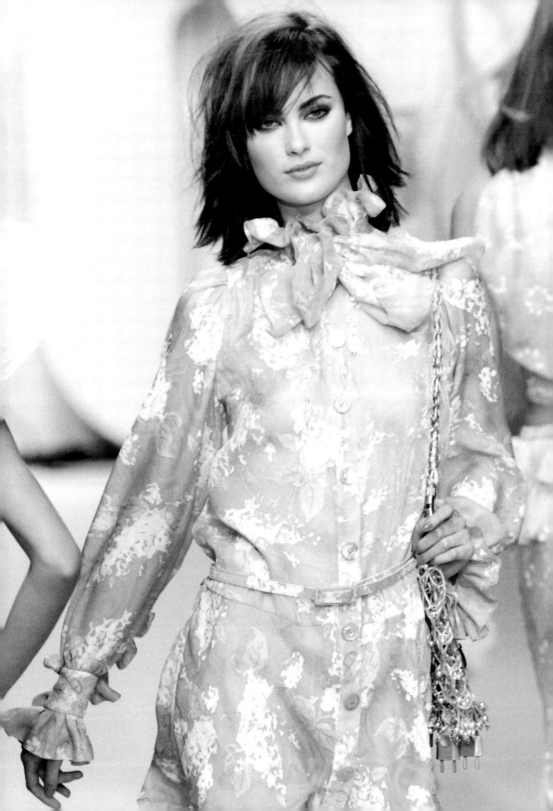

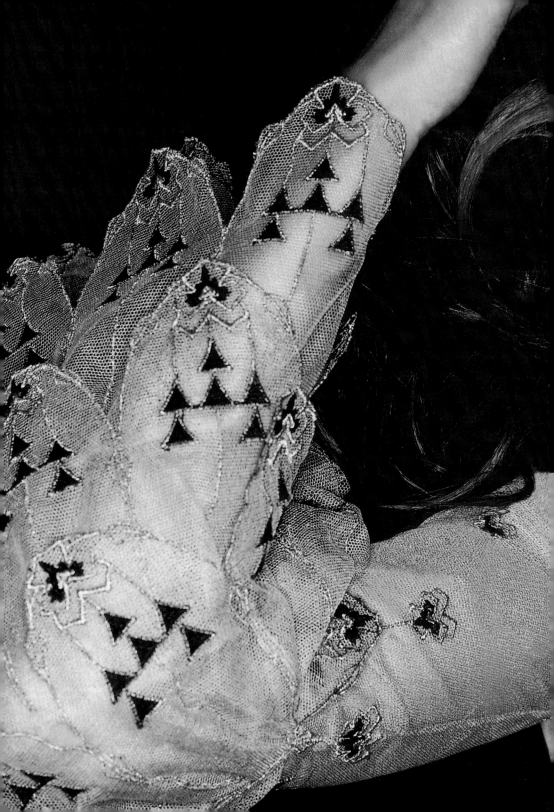

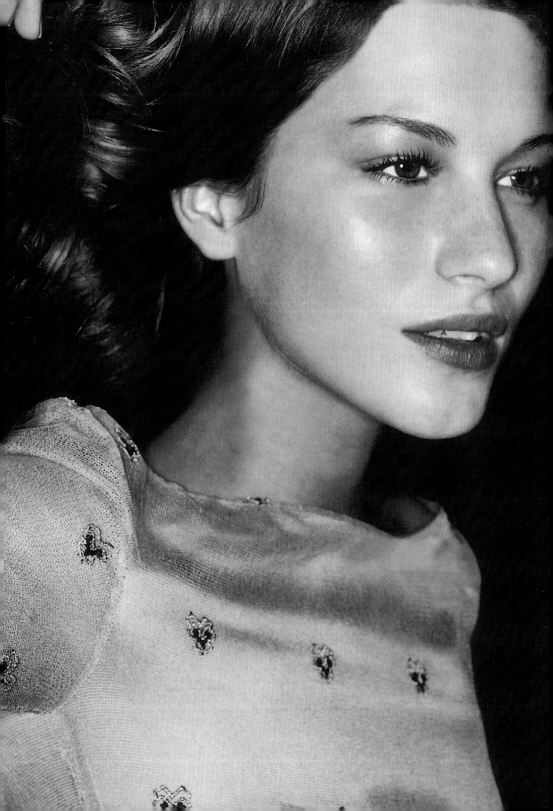

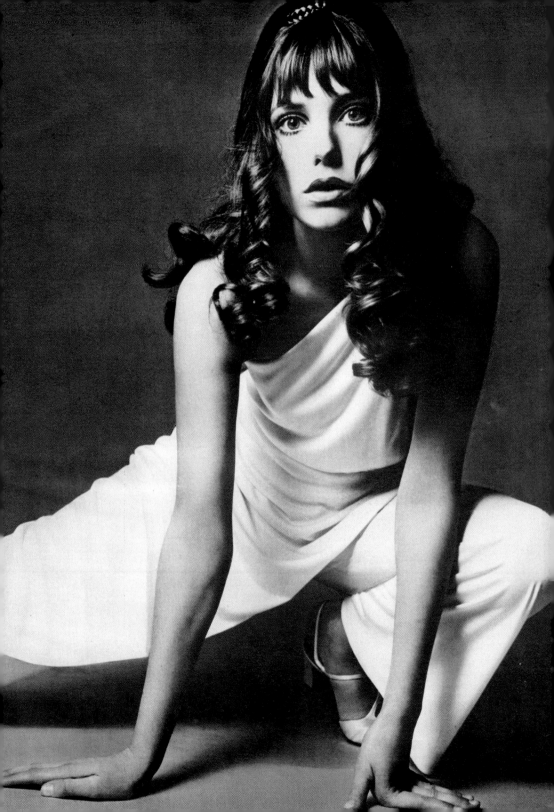

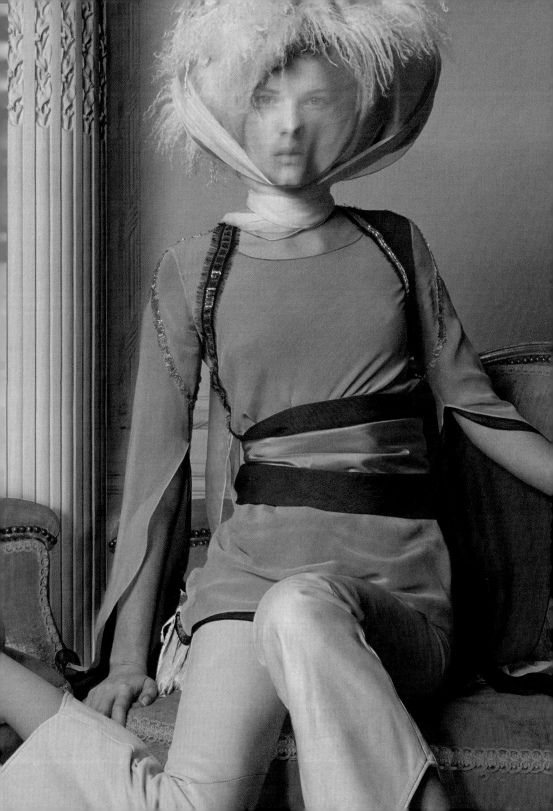

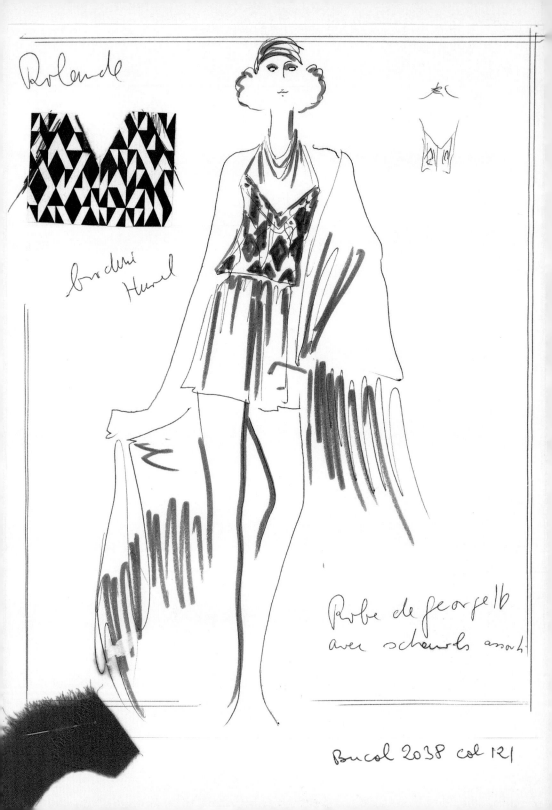

Rolande

broderie
Hurel

Robe de georgette
avec schawls assorti

Bucol 2038 col 121

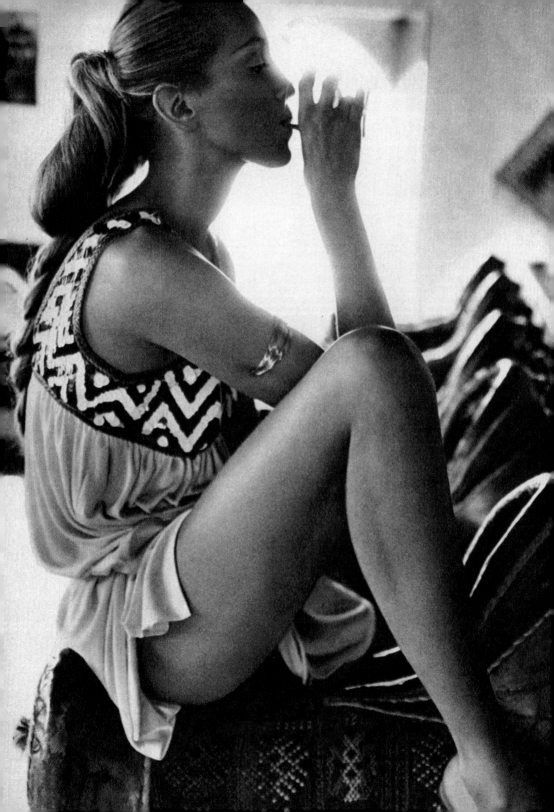

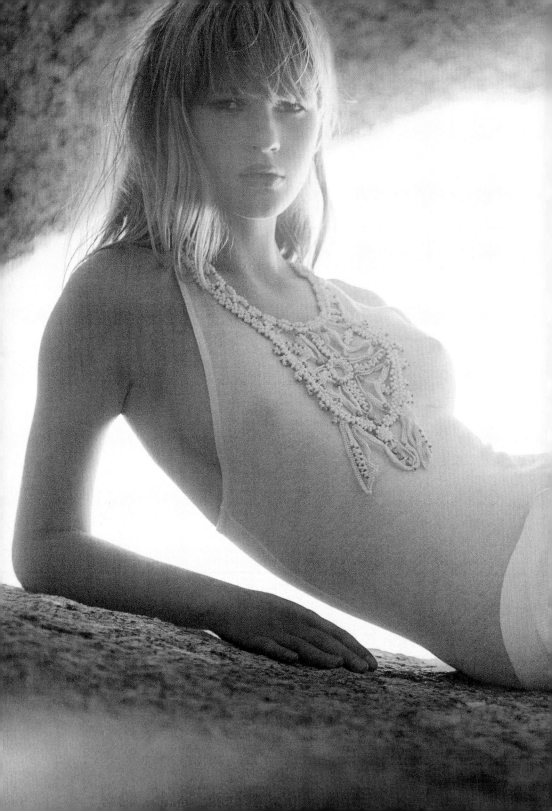

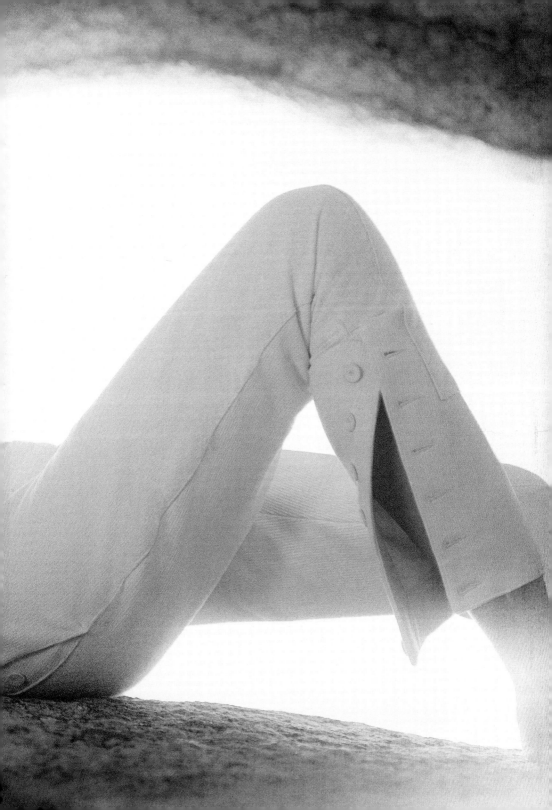

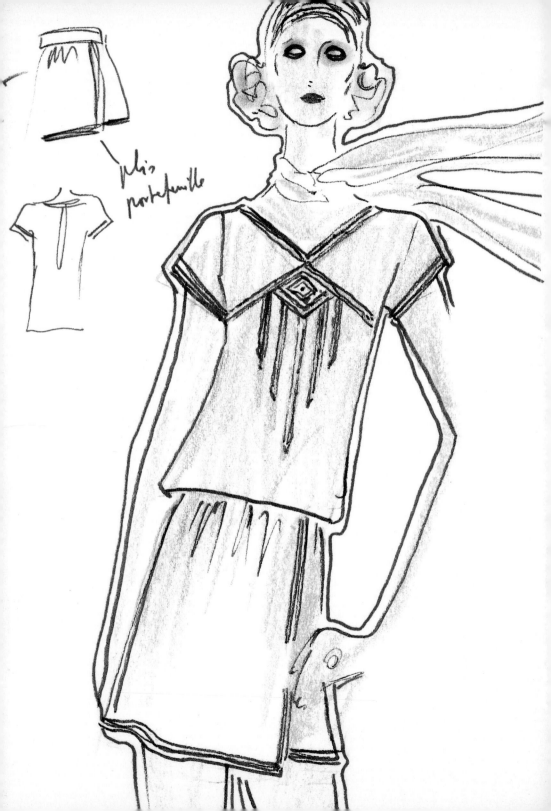

plis portefeuille

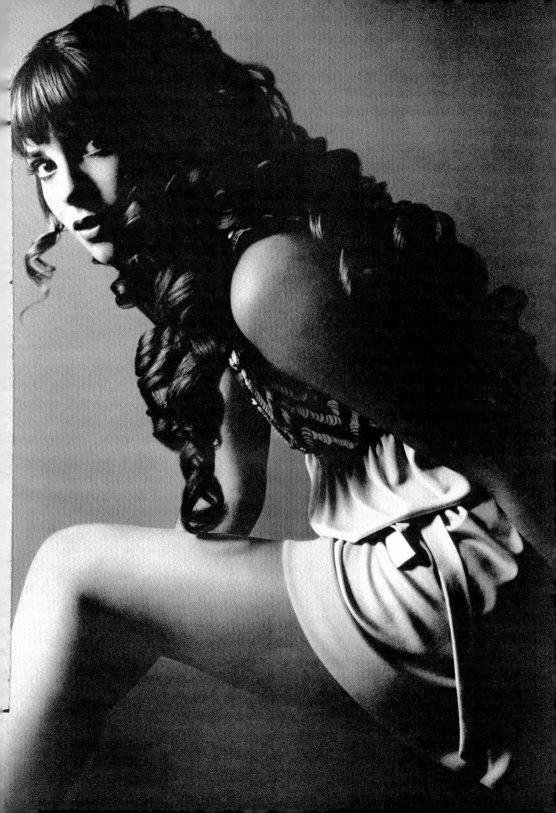

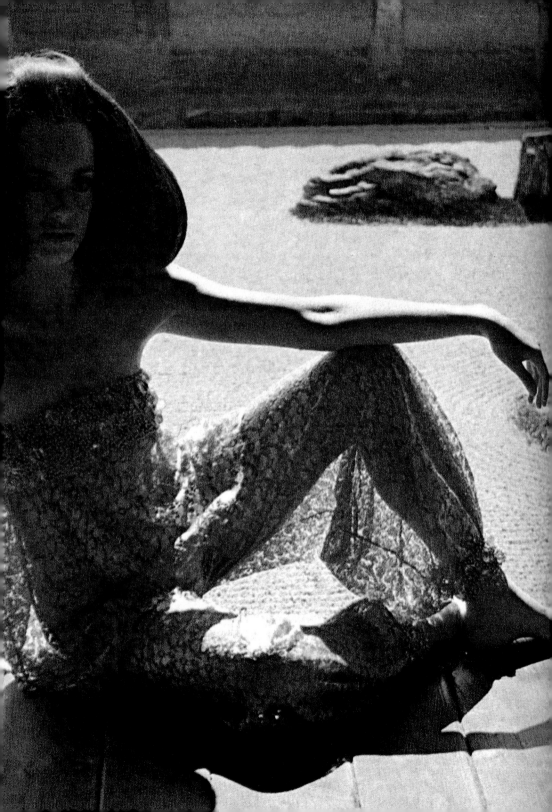

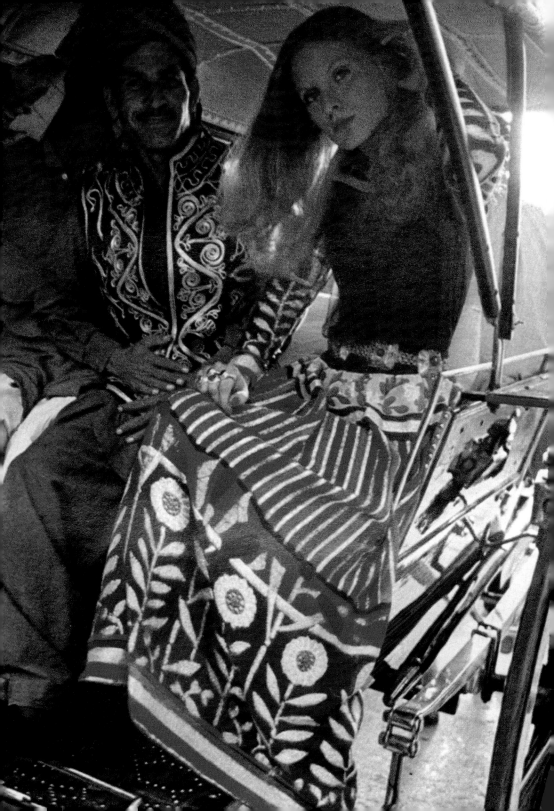

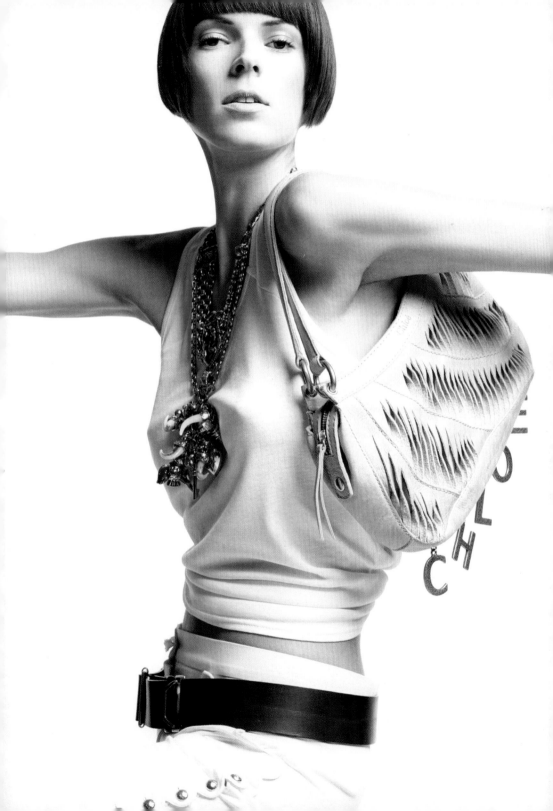

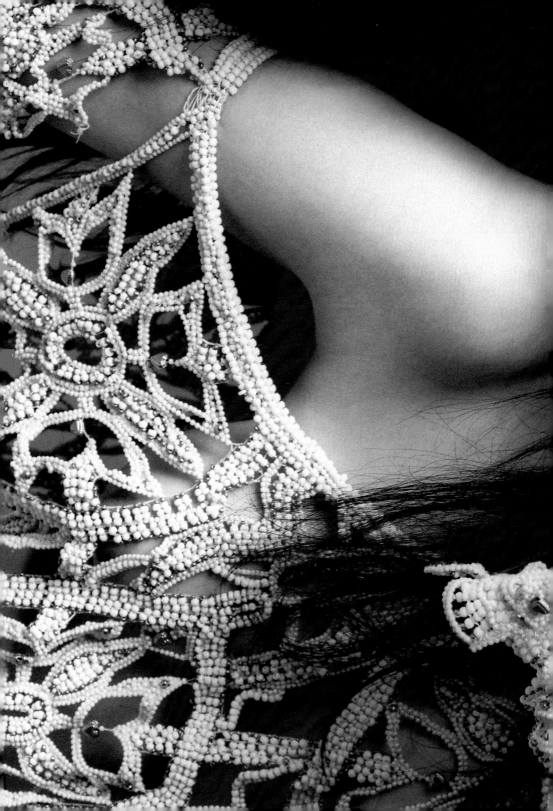

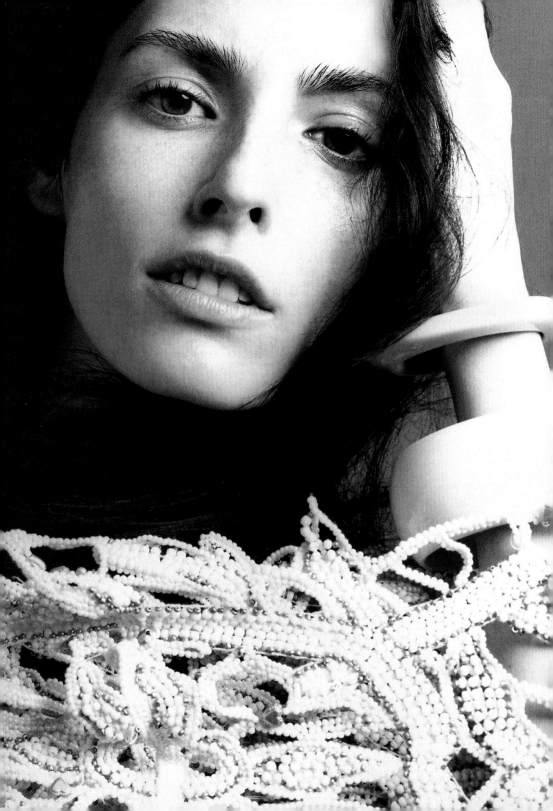

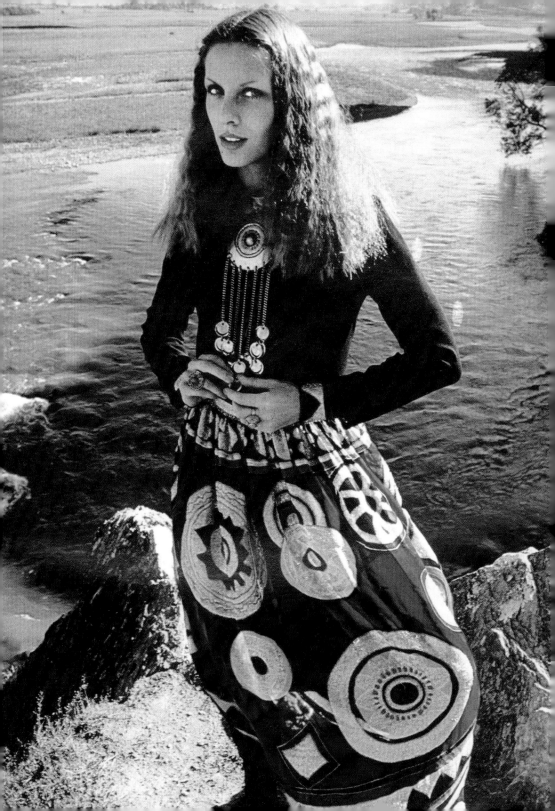

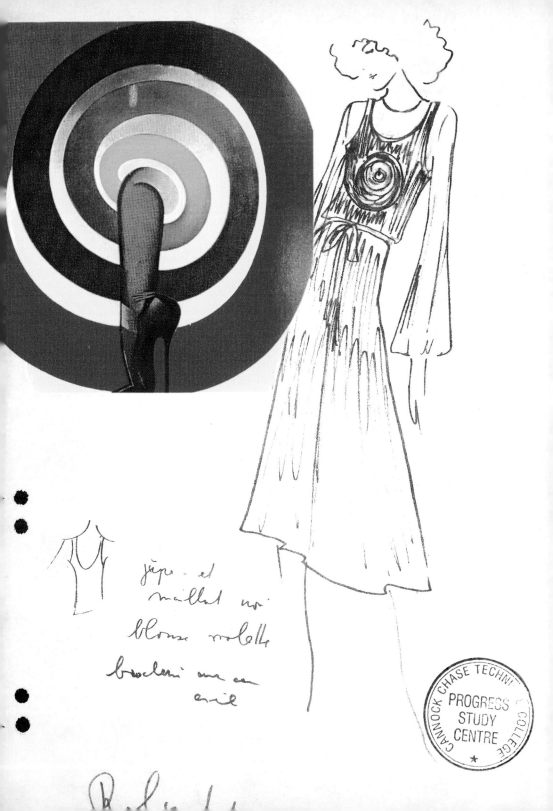

jupe et
maillot noir
blouse violette
bracelet avec au
émail

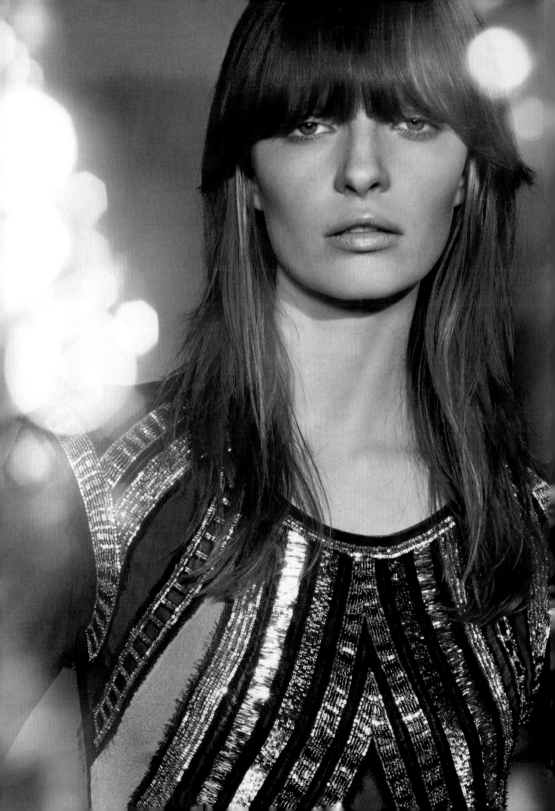

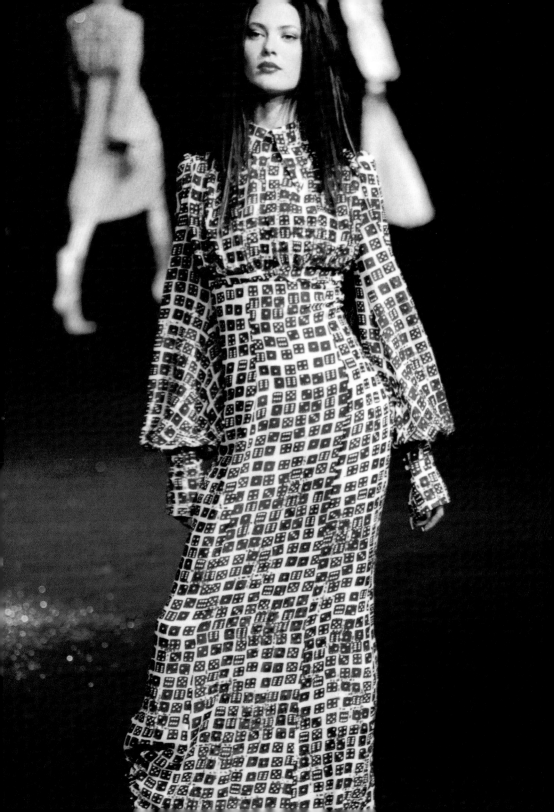

Devenez **Chloé**

"Une Femme ne porte pas mon parfum... elle devient Chloé."

Karl Lagerfeld

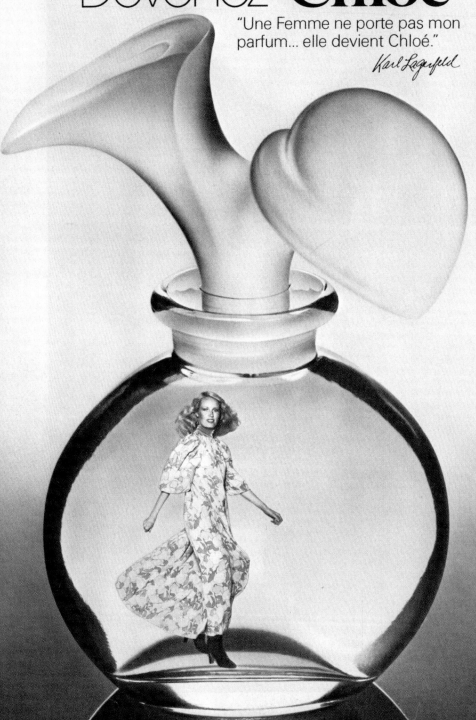

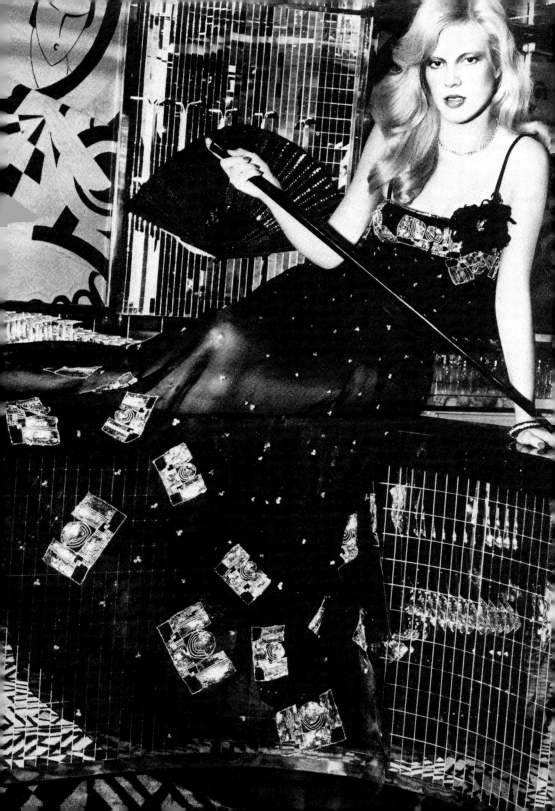

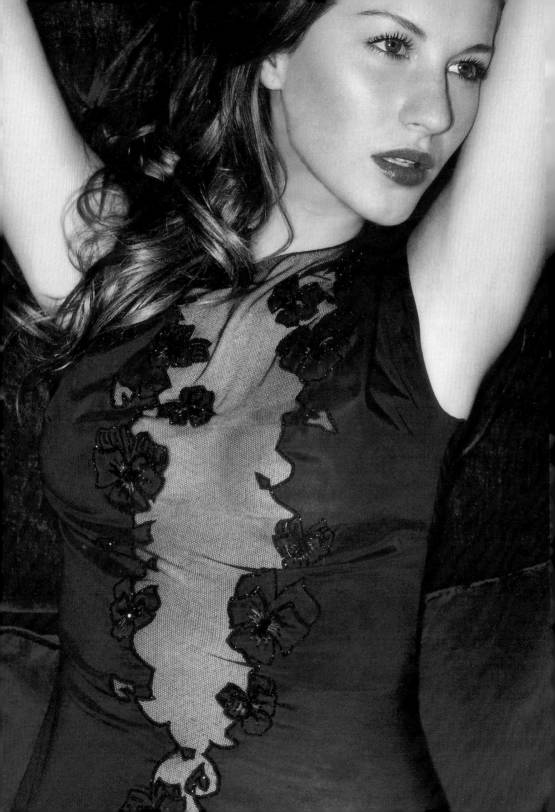

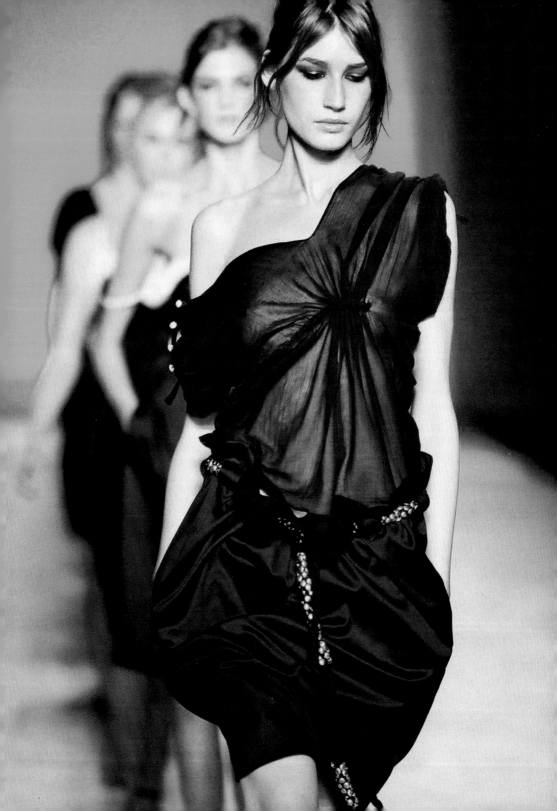

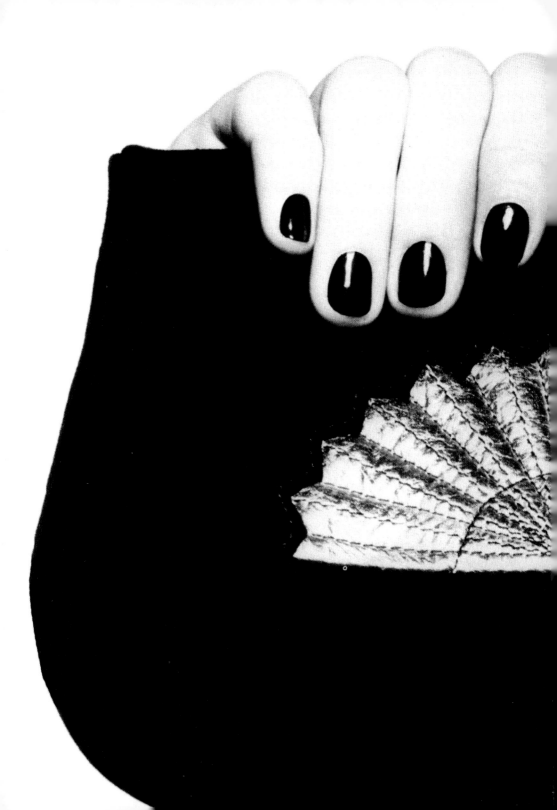

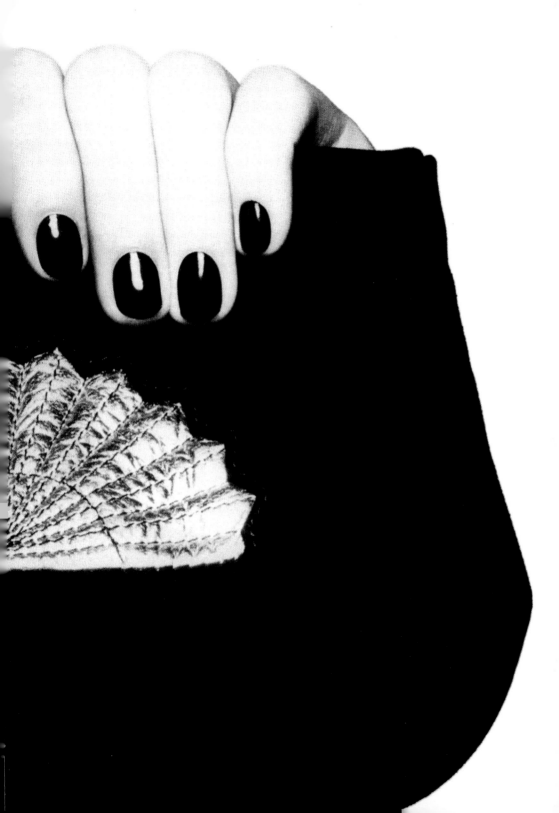

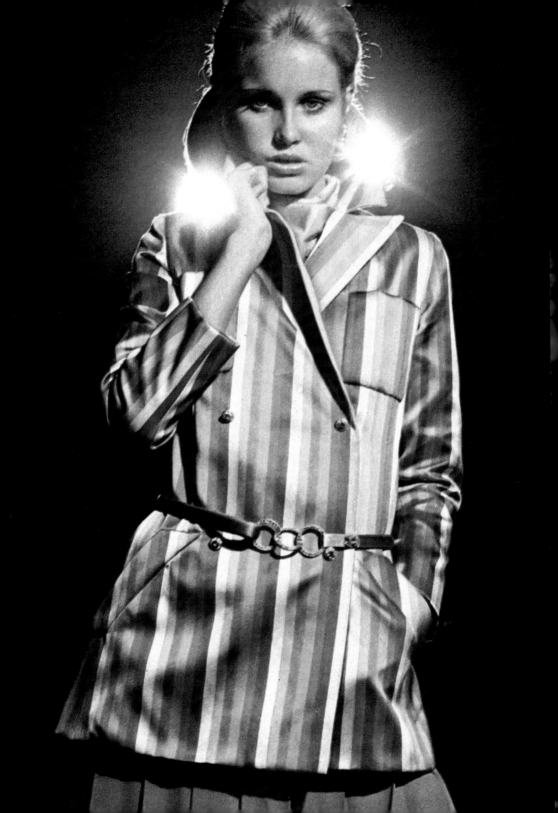

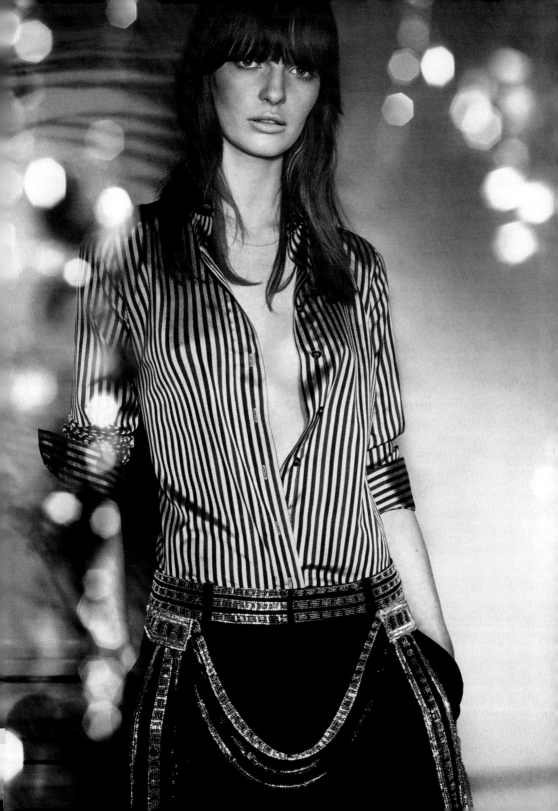

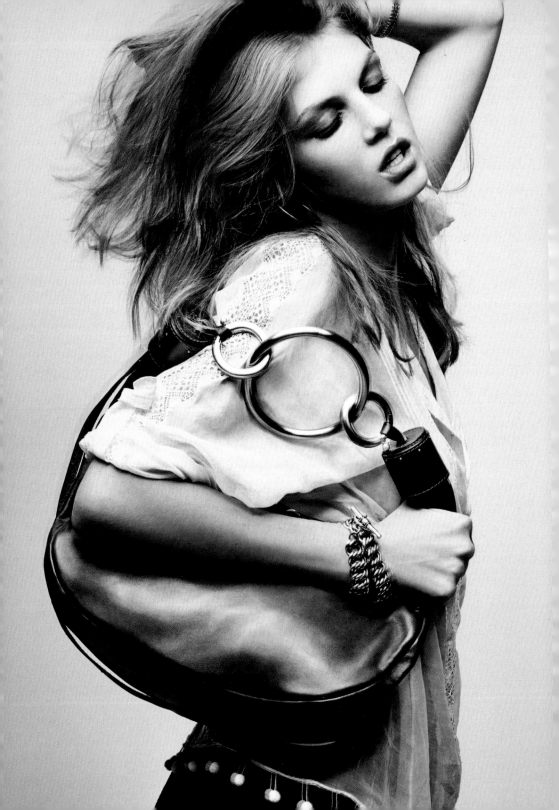

Chronology

1921: March 3rd, Gaby Aghion is born in Alexandria, Egypt.

1945: She moves to Paris.

1952: Creation of Chloé.

1953: Gaby Aghion forms a partnership with Jacques Lenoir.

1956: Chloé's first fashion parade at the Café de Flore, boulevard Saint-Germain in Paris.

1957: Gérard Pipart is hired as a designer.

1964: Christiane Bailly and Maxime de la Falaise work for Chloé.

1965: Karl Lagerfeld arrives at Chloé.

1966: Arrival of the designers Tan Guidicelli and Michèle Rozier.

1971: Opening of the Chloé boutique at 3, rue Gribeauval, in the 7th district of Paris.

1973: Launching of the first Chloé perfume.
Chloé opens a boutique on rue du Faubourg-Saint-Honoré in Paris.

1974: Karl Lagerfeld becomes the exclusive designer at Chloé.

1983: Departure of Karl Lagerfeld.
Arrival of Guy Paulin.

1985: Chloé is bought out by Dunhill Holdings.
Philippe Guibourgé is hired as a designer.
Gaby Aghion and Jacques Lenoir leave Chloé.

1987: Chloé hires Martine Sitbon.

1992: Return of Karl Lagerfeld.

1994: Chloé moves to 54-56, rue du Faubourg-Saint-Honoré in Paris.

1997: Chloé hires Stella McCartney.

1999: Chloé opens a boutique on Madison Avenue in New York.
Creation of Chloé Lunettes.
Opening of a boutique in Hong Kong.

2000: Birth of a second line of ready-to-wear: See by Chloé.

2001: Phoebe Philo becomes the artistic director of the brand.

2002: Chloé opens a boutique on Sloane Street in London.
Creation of small leather goods, handbags and shoes by Chloé.

Cotton veil white blouse and embroidery trimmings. Large bracelet bag in chocolate leather.
Spring/Summer 2003 advertising campaign. © Photo Craig McDean.

Chloé

Black crepe dress with white crepe dickey and bat-wing sleeves. 1971. © Photo Jeanloup Sieff.
Silk jersey cloth dress, graph print. Autumn/Winter 1997 Chloé Fashion Parade. © Archives Chloé.

Top with lavender silk satin flounces and ivory cotton gabardine mini shorts. 1999. © Photo Enrique Badulescu.
Long dress in ivory silk muslin, cuffs embroidered with white and blue pearls. 1968. © Photo Jeanloup Sieff.

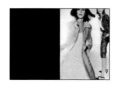

Raglan raincoat with chrome-plated lace on a jersey background. 1964. © Photo Peter Knapp.

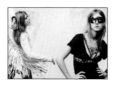

Faded white leather fringed jacket, black silk jeweled dress. Spring/Summer 2003 advertising campaign. © Photo Craig McDean.

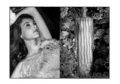

Printed dress in silk and burnout velvet. Fall/Winter Catalogue 1998. © Photo Tom Munro.
Hand-painted doupionne muslin dress. 1966. © Photo Norman Parkinson.

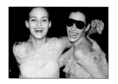

Asymmetrical dress and top with ivory chantilly lace. Autumn/Winter 1999 advertising campaign. © Photo Liz Collins.

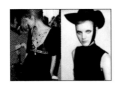

Top model Natalie Portman is wearing a jeweled dress in black silk. Backstage at the Spring/Summer 2003 Chloé fashion parade. © Photo Gauthier Gallet.
High-necked black dress in Lycra and lurex wool crepe. 1995. © Photo Mario Testino.

White silk muslin blouse with waffled organza flounces hemmed with lace. 1967. © Photo André Carrara.
White cotton blouse with a delicate scalloped collar. Spring/Summer 2002 advertising campaign. © Photo Horst Diekgerdes.

Silk blouse embroidered with colored muslin and silver-colored sequins. Autumn/Winter 2002. © Photo Glen Luchford.

Printed Lycra bikini and gold-colored metal tribal necklace. 2002. © Photo Inez van Lamsweerde & Vinoodh Matadin.
Bare-back dress in printed silk muslin. 1965. © Photo Peter Knapp.

Printed cashmere muslin dress. 1977. © Photo Tony Kent.

Portrait of Linda Evangelista by Karl Lagerfeld. Spring/Summer 1994 Chloé Press Kit. © Drawing Karl Lagerfeld.
Printed silk gown. Spring/Summer 1995 Chloé fashion parade. © Archives Chloé.

Silk tulle blouse embroidered with black and gold diamond shapes. Autumn/Winter 1998 Chloé Catalogue. © Photo Tom Munro.

Jane Birkin is wearing a long asymmetrical gown and wide pants in white cotton jersey. 1969. © Photo Guy Bourdin.
Silk muslin blouse with embroidered silver-colored sequins and faded pink leather pants. 2002. © Photo Alix Malka.

Sketch of a gown made for the Spring/Summer 1969 Chloé collection. © Archives Chloé.
Fluid jersey gown in white silk embroidered with sequins. 1969. © Photo Franck Horvat.

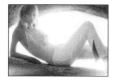

Ivory cotton cashmere top with décolleté embroidered with pearls in matching tones on corduroy jodhpurs. Spring/Summer 2002 advertising campaign. © Photo Horst Diekgerdes.

Sketch of a portefeuille mini-skirt and its matching blouse. Spring/Summer 1969 Chloé Collection. © Archives Chloé.
Jane Birkin is wearing a Greek gown in white silk jersey embroidered with white and black sequins. 1969. © Photo Guy Bourdin.

Bronze toned lace pyjamas. 1967. © Photo Peter Knapp.

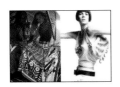

Lamé muslin dress, striped and flowered by hand on a uniform crepe background. 1970. © Photo Peter Knapp.
White cotton tank-top, gold-colored metal tribal necklace and shredded leather bracelet charm bag on white cotton scalloped pants. 2002. © Photo Alix Malka.

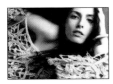

Long gown hemstitched and embroidered with ivory pearls. 2002. © Photo Terry Tsiolis.

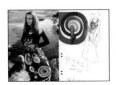

Silver-colored silk muslin table apron on black crepe dress. 1970. © Photo Peter Knapp.
Sketch of a dress and a blouse for the Autumn/Winter 1970 Chloé collection. © Archives Chloé.

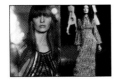

Multicolor silk muslin dress with embroidered silver-colored sequins. Autumn/Winter 2002/2003 advertising campaign. © Photo Horst Diekgerdes.
Long dress in silk muslin with printed dice set off by fuchsia sequins. Autumn/Winter 1997 Chloé fashion parade. © Archives Chloé.

1978 Chloé perfume advertising campaign with the slogan "Become Chloé". © Archives Chloé.
Sylvie Vartan is wearing a long skirt embroidered in black organdie embroidered with silver-colored sequin patterns on a matching trapeze artist leotard. 1968. © Photo Tony Kent.

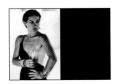

Paloma Picasso is wearing a black jersey dress. 1973. © Photo Helmut Newton.

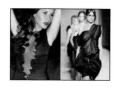

Lycra jersey dress with décolleté adorned in tulle and lace. Autumn/Winter 1998 catalogue. © Photo Tom Munro.
Black cotton veil top with black cotton satin skirt and studded rope belt. Spring/Summer 2003 Chloé fashion parade. © Photo Dann Lecca.

Black silk satin evening clutch. 1979 advertising campaign. © Photo Albert Watson.

Striped silk satin waisted jacket on pleated skirt in pink rayon crepe. 1968. © Photo John Stember.
Striped silk blouse over black crepe shorts with belt embroidered with silver-colored pearls. Autumn/Winter 2002/2003 advertising campaign. © Photo Horst Diekgerdes.

Wall with gold and fuchsia sequins. Spring/Summer 2000 Chloé fashion parade decoration. © Archives Chloé.

The author and publisher would like to thank Gaby Aghion for her help in compiling this book, as well as Jacques Lenoir.

Our thanks go out to the team at Chloé fashion house, in particular Ralph Toledano, Marie Jacoupy and Laurence Stuchlik.

Thanks also to Véronique Ristelhueber and Véronique Bataille.

Finally, this book would not have been possible without the generous contributions of Giselle, Jane Birkin, Shallom Harlow, Kate Moss, Paloma Picasso, Sylvie Vartan, as well as the photographers Enrique Badulescu, Guy Bourdin, André Carrara, Liz Collins, Horst Diekgerdes, Gauthier Gollet, Tony Kent, Peter Knapp, Inez van Lansweerde and Vinoodh Matadin, Angela Lindwall, Glenn Luchford, Alix Malka, Craig McDean, Andrew McPherson, Helmut Newton, Norman Parkinson, Jeanloup Sieff, John Stember, Mario Testino, Terry Tsiolis and Albert Watson.